Cover: Jean-Antoine Watteau, No. 37

Copyright © 1980 by The Metropolitan Museum of Art
ISBN 0-87099-251-1

Published by The Metropolitan Museum of Art
Bradford D. Kelleher, Publisher
John P. O'Neill, Editor in Chief
Polly Cone, Editor
Doris L. Halle and Adrienne Burk, Designers

SEVENTEENTH AND EIGHTEENTH CENTURY

French Drawings

FROM THE ROBERT LEHMAN COLLECTION

CATALOGUE BY
GEORGE SZABO

THE METROPOLITAN MUSEUM OF ART
NEW YORK
1980

INTRODUCTION

This presentation of seventeenth- and eighteenth-century French drawings is the fifth in the series of exhibitions that will eventually make all the drawings in the Robert Lehman Collection available to the public.

This small group of thirty-eight sheets contains many important drawings. Claude Lorrain is represented by four works, and each is an outstanding example. *The Origin of Coral* is the "première pensée" for a later painting, and the sheet with the view of Rome transcends topographical illustration. His *Landscape with Sheep* is a creation unlike any other, and the studies and signature on the verso of this drawing are reproduced here for the first time. Single works, such as the delightful *Procuress* by Lallemand or Silvestre's architectural study, introduce seventeenth-century artists whose work is not widely known.

Among the eighteenth-century drawings, those of Fragonard, Hubert Robert, and Gabriel de Saint-Aubin are outstanding. The *Dessinateur* and the *Fête à Saint-Cloud* have often been exhibited, but the elaborate verso of the latter work is reproduced here for the first time. Some other drawings, like Watteau's *Rommel Pot Player* or Oudry's *Country Farmhouse,* have not been shown for a long time and are not even mentioned in the catalogues raisonnés of these artists' oeuvres.

This catalogue illustrates all the exhibited drawings and several additional versos besides those already mentioned. The attributions are traditional, but, in many cases, the results of new research and suggestions are also incorporated. The bibliographies supply the basic information about provenance and further literature.

As in previous exhibitions, the drawings are exhibited together with contemporary furniture, mirrors, and other objects of decorative art from the Robert Lehman Collection. Especially interesting are some of the eighteenth-century frames and the mat on Hubert Robert's oval drawing, designed and watercolored by Glomy, the well-known Parisian engraver of the second half of the eighteenth century.

The exhibition and the catalogue were prepared by the staff of the Robert Lehman Collection. Conservation work and matting were done by the Department of Paper Conservation. The design of the catalogue, the labels, and the poster are the work of the Design Department. Their collaboration is gratefully acknowledged here.

<div align="right">

George Szabo
Curator
Robert Lehman Collection

</div>

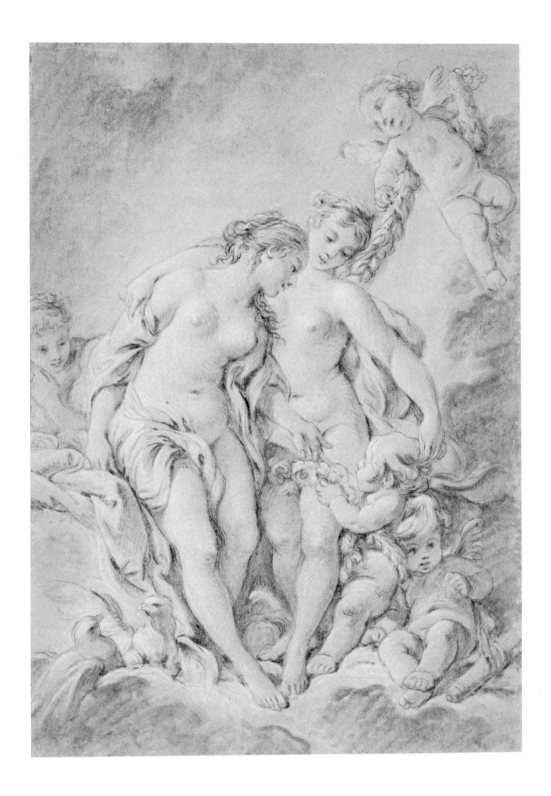

FRANÇOIS BOUCHER, Paris, Rome, 1703–1770

1. *Nymphs and Cupids*

Black chalk, partially stumped and heightened with white chalk on paper, 32.2 x 23.2 cm. The edge of the sheet is outlined in black chalk.

BIBLIOGRAPHY: L. Soulié and C. Masson, *Catalogue raisonné de l'oeuvre peint et dessiné de François Boucher,* Paris, n.d., no.235; E. van Schaack, *Master Drawings in Private Collections,* New York, 1962, p.6, no.70.

Like many of the artist's other drawings, this was intended as a finished work, independent of any painting.

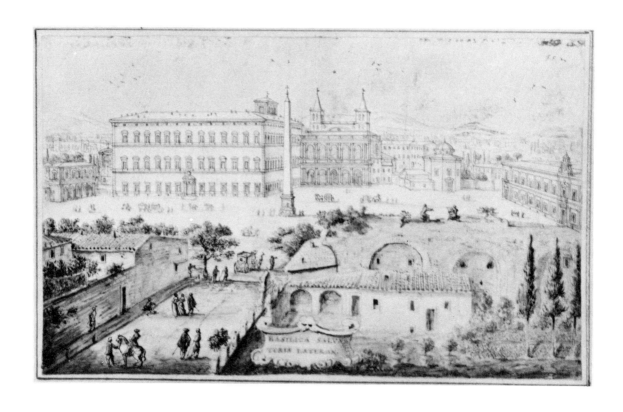

JACQUES CALLOT, Nancy, Rome, Brussels, Paris, 1592–1635

2. View of the Lateran in Rome

Pen and ink, point of brush, and some color on vellum, 9 x 14.2 cm. Initialed in lower right: *J.C.*
Inscribed in lower center in an elaborate cartouche: *BASILICA SALVATORI LATERAN.*
Unpublished.

The attribution to Callot is questionable. However, this might be a copy after one of the artist's drawings made during his stay in Rome between 1608 and 1611. This drawing and the next one were acquired together with a third, a gift of Robert Lehman to the Art Museum, Princeton University, representing the Capitoline Hill.

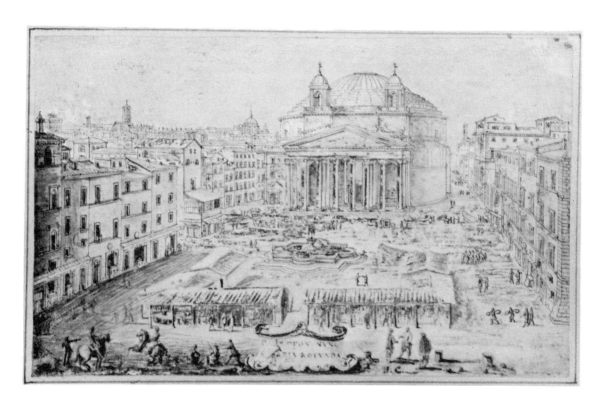

JACQUES CALLOT, Nancy, Rome, Brussels, Paris, 1592–1635

3. *View of the Pantheon in Rome*

Pen and ink, point of brush, and some color on vellum, 8.5 x 14 cm. Initialed in lower right: *J.C.*
Inscribed in center in an elaborate cartouche: *PANTHEON NVNC S. MARIA ROTVNDA.*
Unpublished

Together with the previous drawing and the one in Princeton, this might be part of a series representing the most important sights of Rome. It was a common practice of sixteenth- and seventeenth-century northern artists to compile such pictorial records for further use, possibly to be engraved.

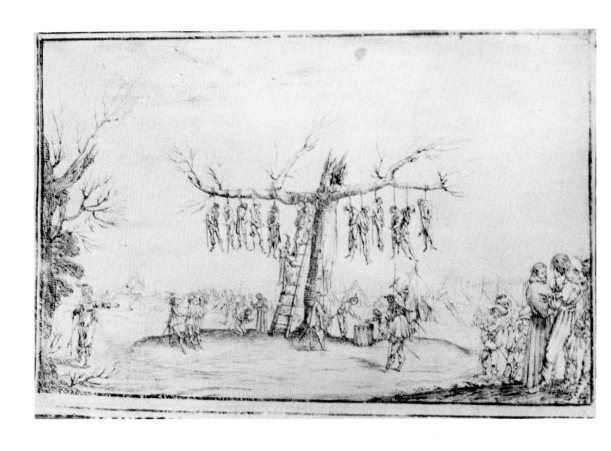

JACQUES CALLOT, Nancy, Rome, Brussels, Paris, 1592–1635

4. *The Hangman's Tree*

Pen and ink on paper, 11 x 17.9 cm.

BIBLIOGRAPHY: Cincinnati, no.257.

The drawing is close but not identical to an etching in the artist's famous *Les Misères et les malheurs de la guerre*, published in Paris in 1633. The drawing and the etchings of the series depict the ravaging of Callot's native Lorrain by the Spaniards (see P. Marot, "Jacques Callot," in Musée Historique Lorrain, *Les Peintres et graveurs lorrains du XVIIe siècle*, Nancy, 1935, pp.35–36).

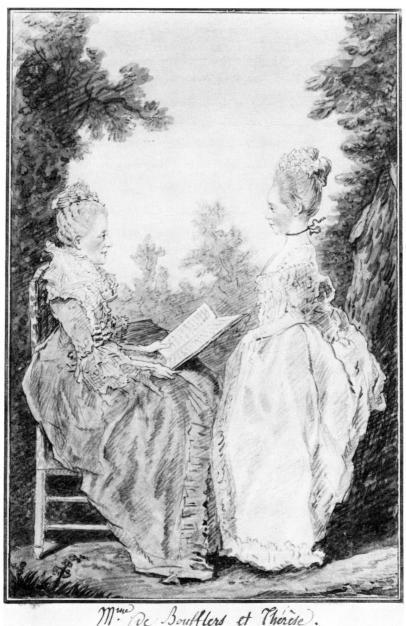

M^{me} de Boufflers et Thérèse.

LOUIS CARROGIS CARMONTELLE, Paris, 1717–1806

5. *Madame de Boufflers and Thérèse*

Black and sanguine crayon with watercolor on paper, 30.4 x 20.5 cm. Inscribed on the old mat in a contemporary hand: *Mme de Boufflers et Thérèse.*

BIBLIOGRAPHY: Cincinnati, no. 260.

The sitter is the countess Boufflers-Rouverel, Marie-Charlotte Hyppolyte de Saujon, who was born in Paris in 1725 and died in 1800. In the drawing she is shown giving a lesson to Thérèse, the daughter of a poor man from Lunéville. The beautiful child was adopted into the household of the countess and carefully educated by her. A similar composition by the artist is also in the Musée Condé in Chantilly (see F.-A. Gruyer, *Les Portraits de Carmontelle*, Paris, 1902, pp. 157–59).

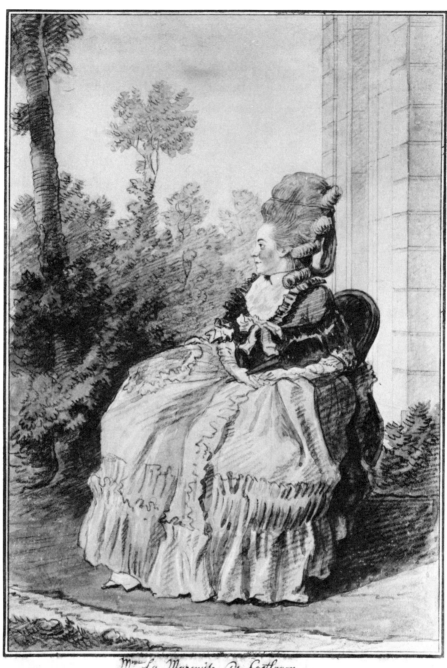

Mᵐᵉ La Marquise de Coëtlogon

LOUIS CARROGIS CARMONTELLE, Paris, 1717–1806

6. *Mme la Marquise de Coëtlogon*

Black and sanguine crayon with watercolor on paper, 31.4 x 21.4 cm.

Unpublished.

The sitter is Françoise-Bernarde-Thérèse-Eugénie de Roy de Vaquières, who in June of 1764 married Alain-Emmanuel-Félicité, Marquis of Coëtlogon, an officer in the regiment of the king. Another portrait of the marquise is in the Musée Condé in Chantilly (see F.-A. Gruyer, *Les Portraits de Carmontelle*, Paris, 1902, p.166).

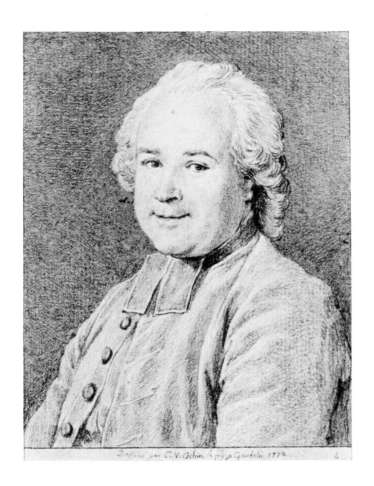

CHARLES-NICOLAS COCHIN, Paris, Rome, 1715–1790

7. *Portrait of the Abbot Pommier, Doyen of the Chapter of Reims*

Pencil on paper, 11.3 x 9 cm. Inscribed below in center: *Dessiné par C.N. Cochin le fils a Gandeleu 1772*. Also inscribed on the verso: *l'Abbe Pommyer conseiller a la gde Chambre du Parlement*.

Unpublished.

An engraving of the same subject is in the Department of Prints and Photographs of The Metropolitan Museum of Art (49.125.186). The print is dated 1768 (see C. A. Jombert, *Catalogue de l'oeuvre de Charles Nicolas Cochin fils*, Paris, 1770, p.130, no.104).

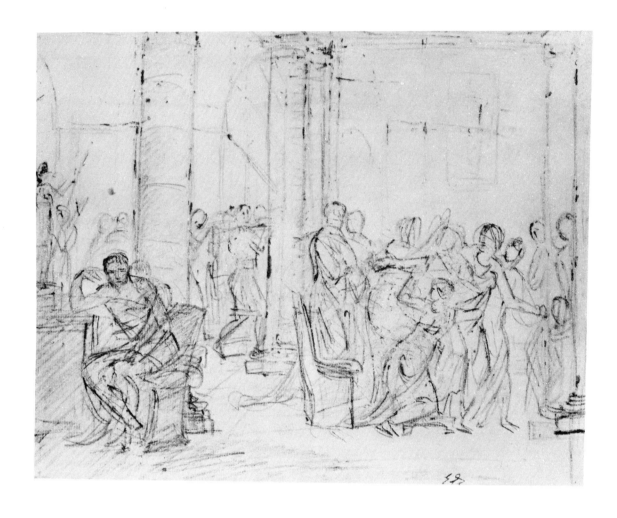

JACQUES-LOUIS DAVID, Paris, Rome, Brussels, 1748–1825

8. *Lictors Returning to Brutus the Bodies of His Sons*

Black and brown chalk on paper, 23.9 x 30.8 cm. Initialed in lower right by the artist's son Eugene David: *E.D.*

BIBLIOGRAPHY: R. L. Herbert, *David, Voltaire, Brutus and the French Revolution: An Essay in Art and Politics,* New York, 1971, pp. 21–22.

This is a study for the artist's famous painting of the same title in the Louvre, which was conceived in 1787 and completed during the first summer of the Revolution for exhibition at the Salon in September, 1789. R. L. Herbert dates this drawing to about 1788 and remarks that "the drawing has the complexity of David's rather baroque early works," which "will be greatly reduced in the finished picture."

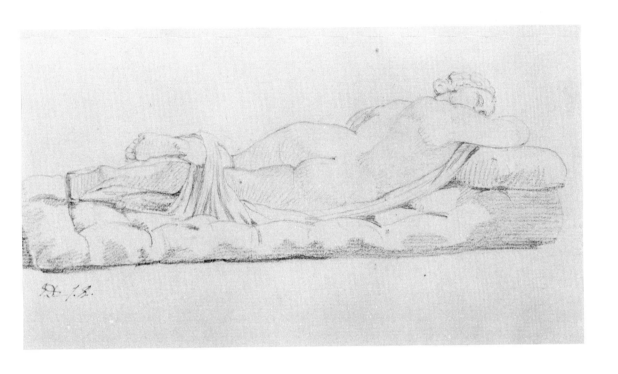

JACQUES-LOUIS DAVID, Paris, Rome, Brussels, 1748–1825

9. *Hermaphrodite*

Black chalk on paper, 13.6 x 21.1 cm. Initialed in lower left corner: *J.D. E.D.*

BIBLIOGRAPHY: Jacques Seligman & Co., Inc., *Master Drawings*, New York, 1962, no.11.

The two sets of initials are those of the artist's sons, Jules David and Eugene David. They were affixed at the time of the atelier sales of the artist's works in 1826 and 1835. The present drawing is from the "Album Factice No. 10" of these sales.

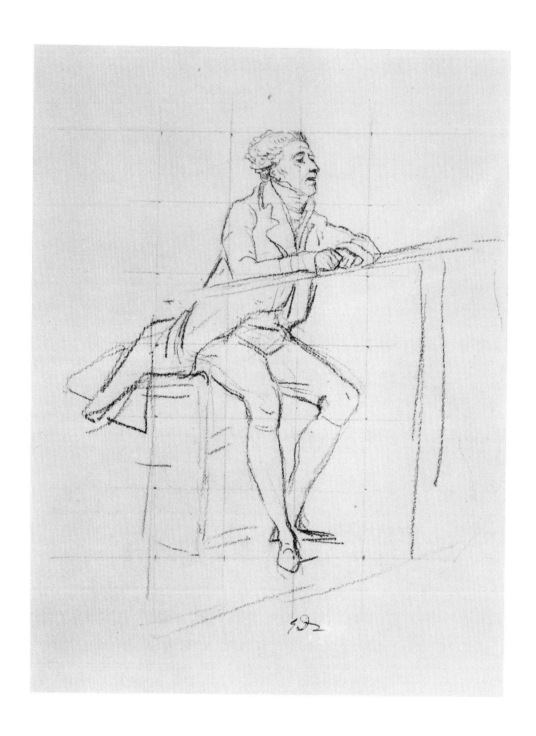

JACQUES-LOUIS DAVID, Paris, Rome, Brussels, 1748–1825

10. *Seated Gentleman*

Black chalk on paper squared for transfer, 23 x 17.7 cm. Initialed in lower center by the artist's son Eugene David: *E.D.*

BIBLIOGRAPHY: J. David, *Le Peintre Louis David, par Jules David, son petit-fils,* Paris, 1880–83, fasc. 19, p.661.

The drawing was engraved by the artist's grandson, Jules David, who describes the figure as "a seated person, fine and distinguished, resting his arms on a balustrade, study for 'The Distribution of the Eagles' 1810." This monumental work is now in Versailles (A. Maurois, *J. L. David,* Paris, 1948, no.32).

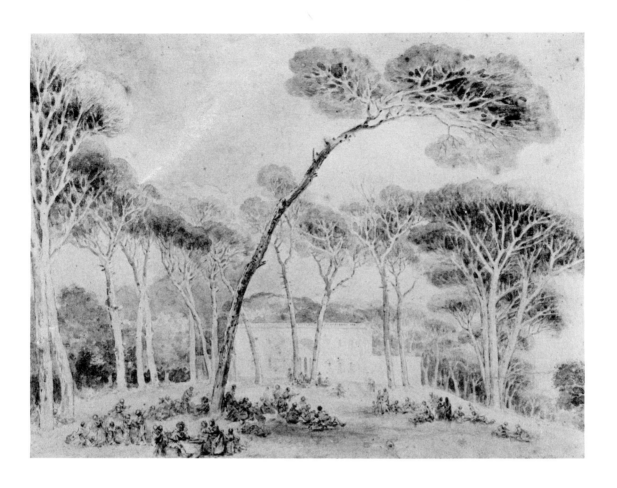

JEAN-HONORÉ FRAGONARD, Grasse, Rome, Naples, Venice, Paris, 1732–1806

11. *View of the Pincio in Rome*

Pen and brown ink with brown wash on paper, 28.6 x 39.1 cm.

BIBLIOGRAPHY: Paris, no.96; Cincinnati, no.264; A. Ananoff, *L'Oeuvre dessiné*, vol.II, no.1441, vol.IV, p.425; The Metropolitan Museum of Art, *French Drawings and Prints*, exhibition catalogue, New York, 1972, no.21.

Judging from the style—the profuse use of wash—the drawing is from the time of the artist's second journey to Italy in 1773–74. Like the previous drawing, this was in the collection of the Goncourt brothers.

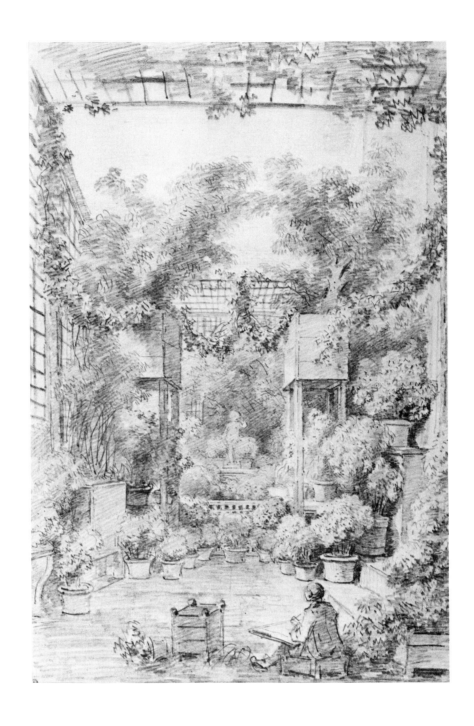

JEAN-HONORÉ FRAGONARD, Grasse, Rome, Naples, Venice, Paris, 1732–1806

12. *The Draftsman (Le Dessinateur)*

Black chalk on white antique paper, 34.6 x 24.2 cm. Signed on the old mat: *Fragonard*.

BIBLIOGRAPHY: A. Ananoff, *L'Oeuvre dessiné,* vol.II, no.650, vol.IV, p.374; E. Munhall, "Fragonard's Studies for the Progress of Love," *Apollo* 93 (1971), pp.404–6; Guidebook, p.105, pl.191; *Drawings by Fragonard in North American Collections*, no.21; J. M. Massengale, "Drawings by Fragonard in North American Collections," *The Burlington Magazine* 121 (1979), p.271.

This important drawing is characterized by "superb control of draftsmanship and skill in illusionistic effects." Generally it is dated to the 1770s. However, a date in the 1780s has recently been proposed.

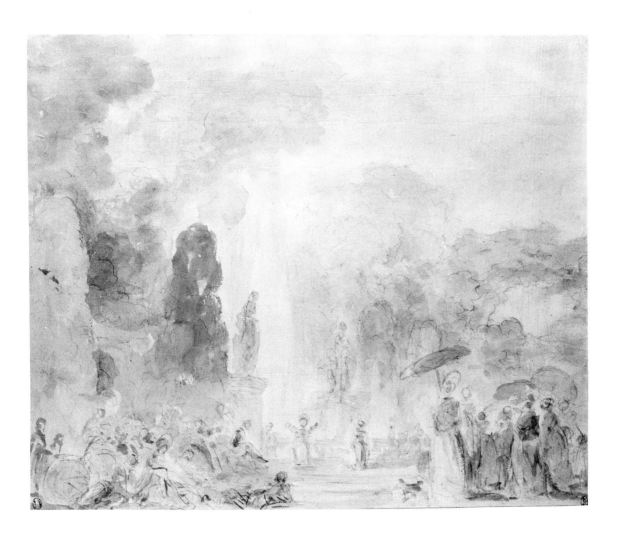

JEAN-HONORÉ FRAGONARD, Grasse, Rome, Naples, Venice, Paris, 1732–1806

13a. *Fete at Saint-Cloud (Fête à Saint-Cloud)*

Black chalk and graphite, gray wash, and watercolor with brush on antique paper, 34.3 x 42.5 cm. On the verso: No. 13b.

BIBLIOGRAPHY: R. de Portalis, *Fragonard*, vol.I, p.81; Paris, no.97, A. Ananoff, *L'Oeuvre dessiné*, vol.II, no.790; G. Wildenstein, "La Fête de Saint-Cloud et Fragonard," *Gazette des Beaux Arts* 55 (1960), pp.46–47, fig.2; *Drawings by Fragonard in North American Collections*, no.39.

The light and transparent effects of this work are somewhat overemphasized by a slight fading of the watercolor. Nevertheless, the drawing retains the immediacy of the *première pensée*— the first inception of a composition. It is, in fact, a preliminary study for part of a painting of the same title (now in Paris, Banque de France) commissioned about 1775 by the duc de Penthièvre. It is also related to a gray wash drawing in the Rijksmuseum, Amsterdam, that is a more finished work and, curiously enough, closer to the drawing on the verso of this sheet (see No. 13b).

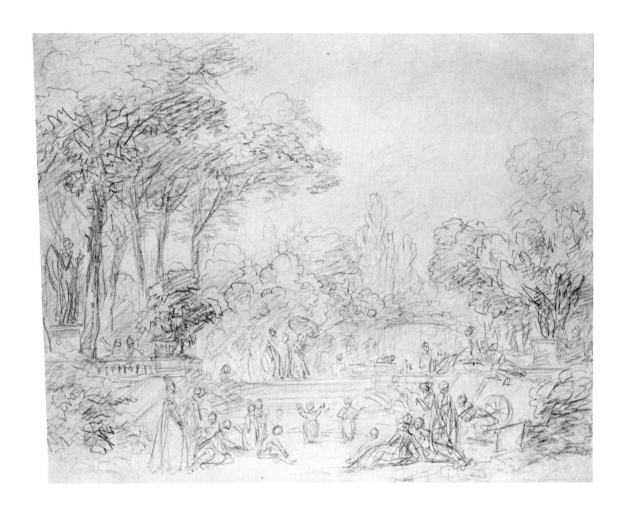

JEAN-HONORÉ FRAGONARD, Grasse, Rome, Naples, Venice, Paris, 1732–1806

13b. *Fete at Saint-Cloud (Fête à Saint-Cloud)*

Black chalk, 34.3 x 42.5 cm. Verso of No. 13a.

BIBLIOGRAPHY: Galerie Georges Petit, *Catalogue des dessins, aquarelles, gouaches, composant la collection de M. A. Beurdeley,* Paris, March, 1905, no.80; A. Ananoff, *L'Oeuvre dessiné,* vol.II, no.790, p.86; *Drawings by Fragonard in North American Collections,* no.39.

Although this drawing has been mentioned and described in various publications, it has never before been reproduced. The composition, contrary to many descriptions, is closer to a drawing in the Rijksmuseum, Amsterdam, than to the painting or to the recto.

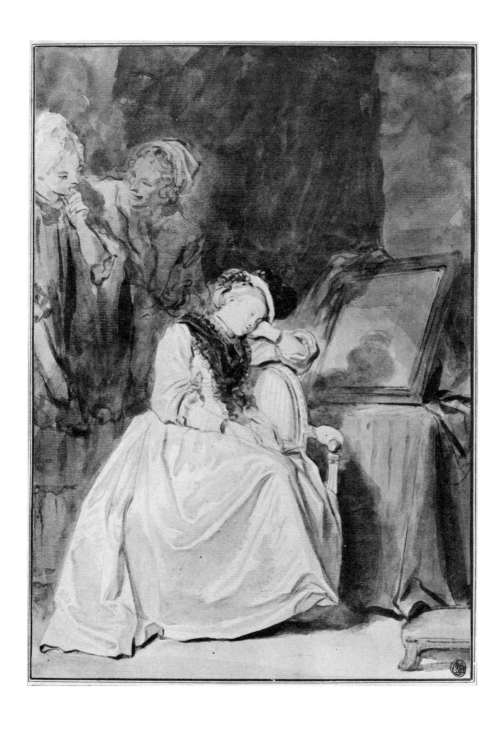

JEAN-HONORÉ FRAGONARD, Grasse, Rome, Naples, Venice, Paris, 1732–1806

14. *The Dreamer (La Rêveuse)*

Brown ink and wash with watercolor and graphite underdrawing on cream paper, 30.5 x 21.5 cm.

BIBLIOGRAPHY: R. de Portalis, *Fragonard*, vol.I, p.305, pl.140; Galerie Charpentier, *Collection Gabriel Cognacq*, Paris, May, 1952, no.1; A. Ananoff, *L'Oeuvre dessiné*, vol.I, no.58, vol.II, p.295; *Drawings by Fragonard in North American Collections*, no.48.

This sheet presents an excellent example of the artist's virtuoso use of ink and brush; the bold contrasts of light and dark seen here might be the result of Rembrandt's influence on Fragonard. An earlier but similarly finished version is the drawing in the Forsyth Wickes Collection of the Museum of Fine Arts, Boston.

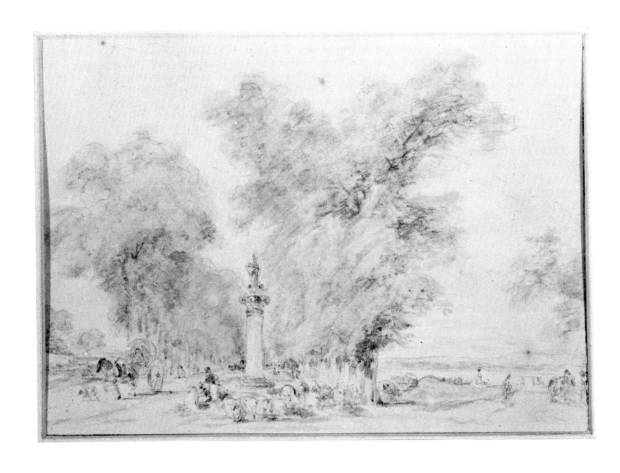

JEAN-HONORÉ FRAGONARD, Grasse, Rome, Naples, Venice, Paris, 1732–1806

15. *Landscape with Road and Monument*

Pencil and ink with washes on paper, 15.6 x 22.2 cm.

Unpublished.

Although it was formerly called "Life in the Park at Fontainebleau," this drawing probably represents a country crossroad and a columnar monument surmounted by figures of the Virgin and Child.

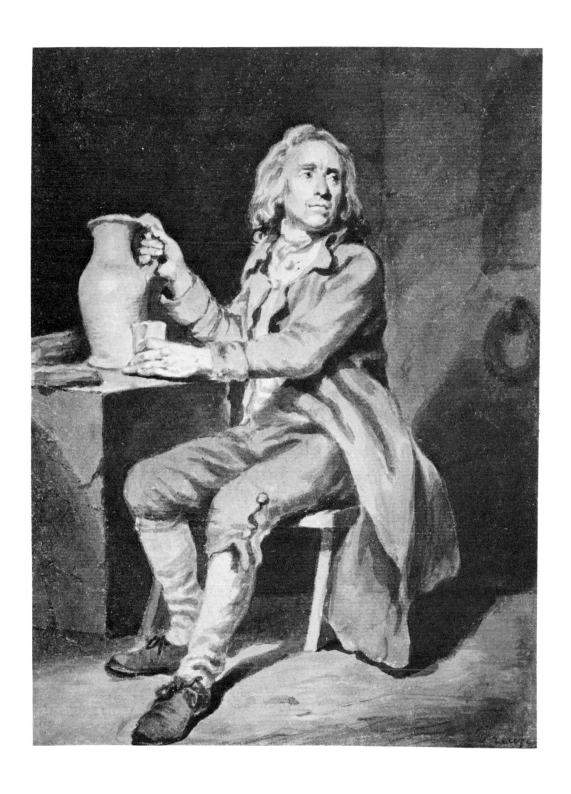

JEAN-BAPTISTE GREUZE, Tornus, Lyon, Rome, Paris, 1725–1805

16. *Man with Pitcher and Glass*

Brush with Chinese ink and wash on paper, 30 x 22.2 cm. Signed in lower right corner: *Greuze.*

BIBLIOGRAPHY: H. G. Gutekunst, *Katalog Wertvoller und Seltener Handzeichnungen aus der Sammlung des Herrn Landgerichtsrats a. D. Peltzer in Köln*, Stuttgart, May, 1914, no.161.

It has been suggested that this highly finished drawing represents a prisoner.

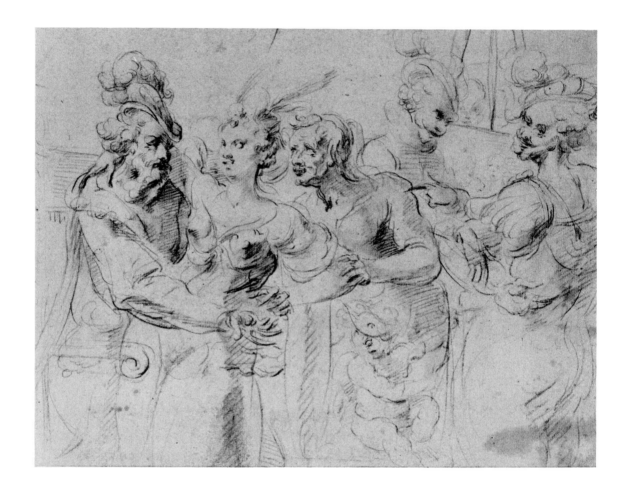

GEORGES LALLEMAND, Nancy, Paris, about 1598–1640

17. *The Procuress*

Pencil on paper, 20.3 x 26.3 cm.

BIBLIOGRAPHY: D. Sutton, "The Literature of Art," *The Burlington Magazine* 98 (1956), p.27; Charles E. Slatkin Galleries, *French Master Drawings, Renaissance to Modern, A Loan Exhibition*, New York, 1959, no.17.

The subject of this animated drawing must have been popular. It exists in two more versions in the Musée Lorrain in Nancy and in a private collection (see F.-G. Pariset, "Georges Lallemant émule de Jacques de Bellange," *Gazette des Beaux Arts* 43 (1954), pp.304–6).

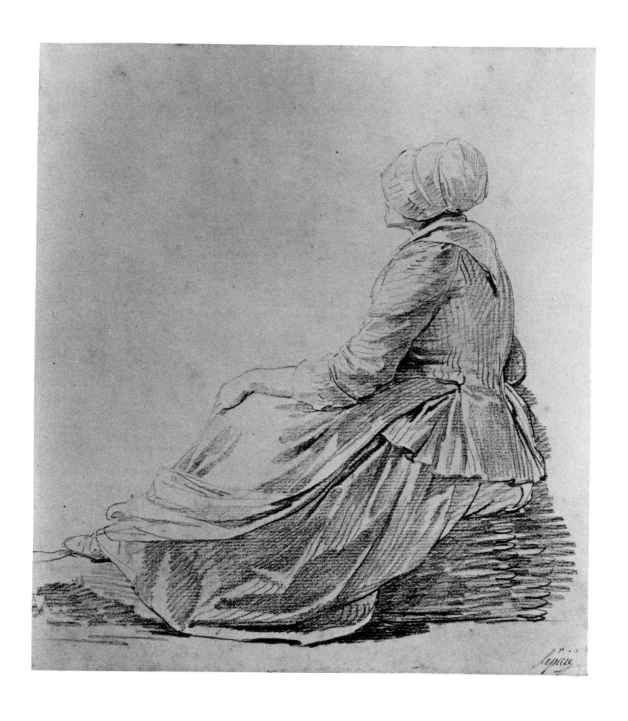

NICOLAS BERNARD LÉPICIÉ, Paris, 1735–1784

18. *Seated Woman*

Black and sanguine crayon on paper, 21.5 x 19 cm. Signed in lower right corner in ink: *Lépicié.*

BIBLIOGRAPHY: Galerie Charpentier, *Tableaux et dessins anciens: Collection de M. Paul Chevalier,* Paris, March, 1956, no.67.

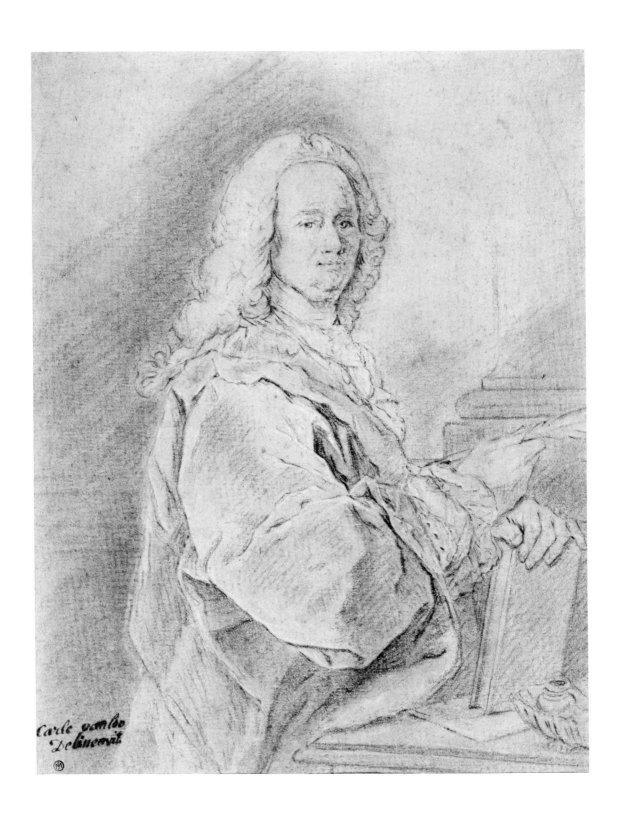

CARLE VAN LOO, Nizza, Rome, Turin, Paris, 1705–1765

19a. *Portrait of a Man with Pen*

Black chalk on paper, 29.4 x 22.6 cm. Signed in ink in lower left corner: *Carle van Loo Delineavit.* On the verso: No. 19b.

Unpublished.

It has been suggested that this penetrating drawing might be a self portrait. If so, it would be dated between 1750 and 1760, during which time the painter was named rector of the Royal Academy (1754), "Premier peintre du Roi" (1762), and finally director of the Academy (1763).

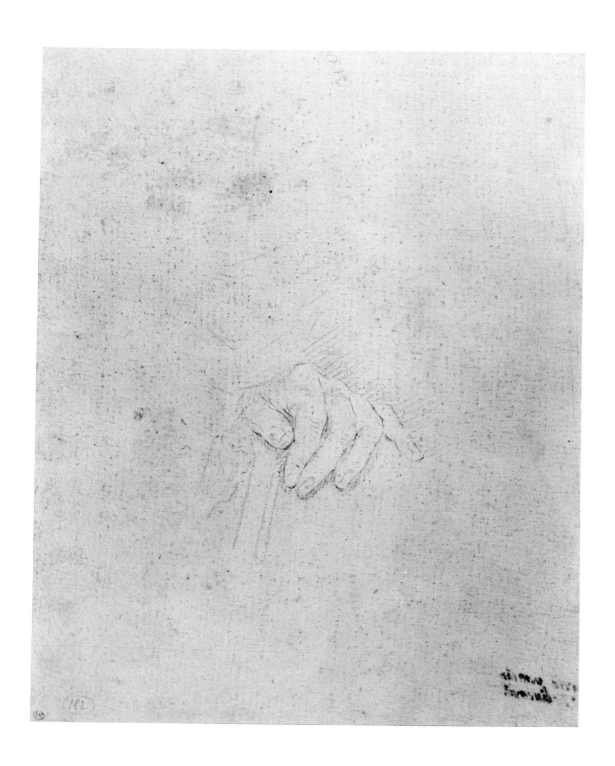

CARLE VAN LOO, Nizza, Rome, Turin, Paris, 1705–1765
19b. *Study of Left Hand*
Black chalk on paper, 29.4 x 22.6 cm. Verso of No. 19a.
Unpublished.
Study for the left hand of the person represented on the recto.

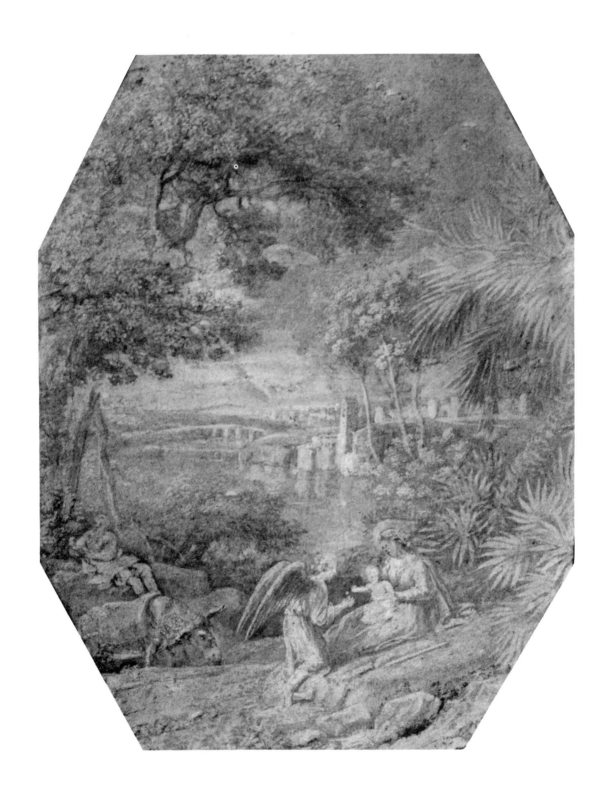

CLAUDE GELLÉE, CALLED LE LORRAIN, Nancy, Rome, Naples, 1600–1682

20. *Landscape with the Rest on the Flight into Egypt*

Point of brush in brown wash heightened with white on blue paper, 23.8 x 19 cm.

BIBLIOGRAPHY: M. Roethlisberger, *Claude Lorrain, the Drawings*, Berkeley, 1968, no. 570.

This is a drawing after a painting of the same subject painted by Claude for Count Crescenzi in 1645 and now in the Cleveland Museum of Art. It is usually dated about 1645 or shortly thereafter.

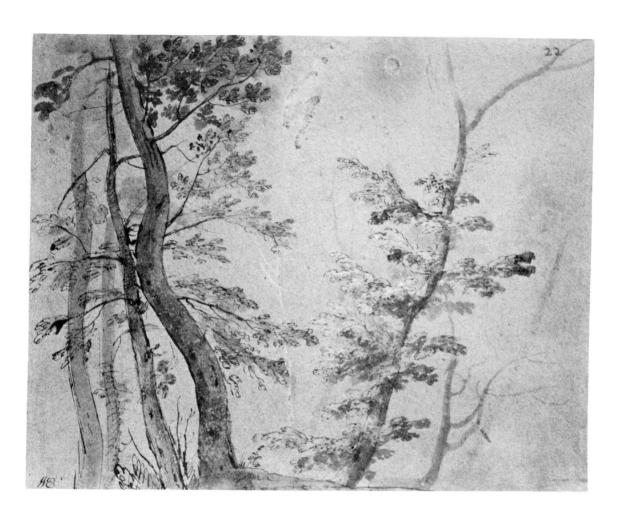

CLAUDE GELLÉE, CALLED LE LORRAIN, Nancy, Rome, Naples, 1600–1682

21. *Trees*

Pen and ink with wash on blue paper, 20 x 26 cm.

BIBLIOGRAPHY: Ira Moskowitz, ed., *Great Drawings of All Time*, vol.III, New York, 1962, no.668; J. Vallery-Radot, *Drawings of the Masters: French Drawings from the 15th Century Through Géricault*, New York, 1964, p.24, no.16.

This attribution is sometimes questioned. However, if it is by Claude, this drawing should be dated to the 1640s.

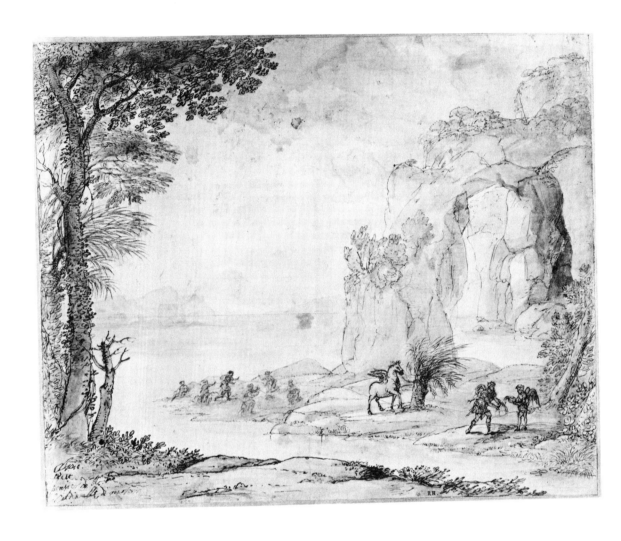

CLAUDE GELLÉE, CALLED LE LORRAIN, Nancy, Rome, Naples, 1600–1682

22. The Origin of Coral

Pen and brown ink with brown wash on paper, 25.4 x 33.3 cm. Inscribed in lower left corner: *Claudio fecit pensier de...Cardinalle di Massimi.*

BIBLIOGRAPHY: C. de Tolnay, *History and Technique of Old Master Drawings*, New York, 1943, no.233; L. L. Boyer, "The Origin of Coral by Claude Lorrain," *The Metropolitan Museum of Art Bulletin* 26 (1968), pp.372–79.

This drawing is the earliest of six known studies for the painting of the same title commissioned by Cardinal Carlo Camillo Massimi in 1674 (collection of Lord Leicester, Holkham Hall, Norfolk). L. L. Boyer dates this drawing to 1672 and discusses it in connection with the most finished drawing of the six, which is in the Department of Drawings in this museum.

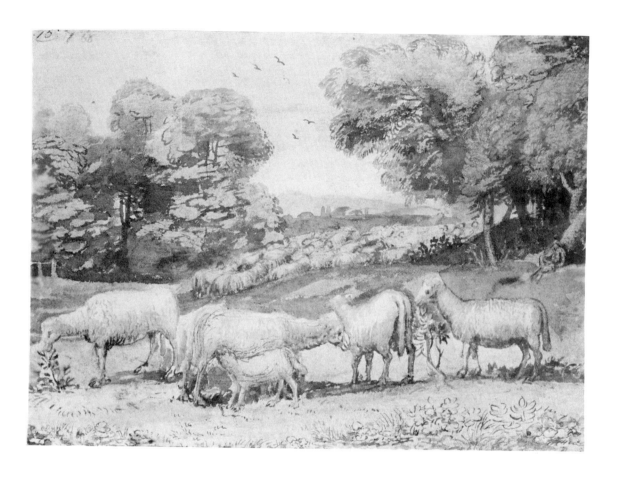

CLAUDE GELLÉE, CALLED LE LORRAIN, Nancy, Rome, Naples, 1600–1682

23a. *Landscape with Sheep*

Black chalk, brown wash, pen, and brush on paper, 18.1 x 26.4 cm. Inscribed in upper left corner with the numbers *15* and *68*. On the verso: No. 23b.

BIBLIOGRAPHY: M. Roethlisberger, *Claude Lorrain, the Drawings*, Berkeley, 1968, no.666.

The catalogue raisonné states that "this composition is an independent pictorial image in its own right." The date, 1648, on the verso, is in accordance with other works from this period by this artist. In spite of earlier opinions, this drawing is not a study for a small painting of sheep in the Academy in Vienna.

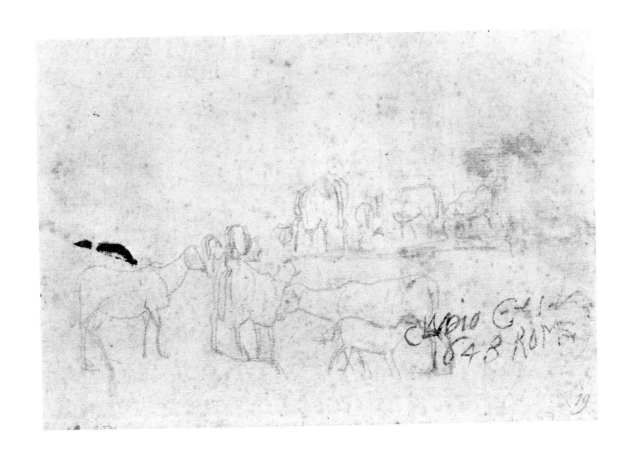

CLAUDE GELLÉE, CALLED LE LORRAIN, Nancy, Rome, Naples, 1600–1682

23b. *Studies of Sheep and Shepherd*

Black chalk, 18.1 x 26.4 cm. Inscribed in ink in lower right corner with the numbers *68* and *19* and *CLAUDIO G.I.V. 1648 ROME*. Verso of No. 23a.

BIBLIOGRAPHY: M. Roethlisberger, *Claude Lorrain, the Drawings*, Berkeley, 1968, no.666.

The four sheep at the bottom are traced through. Directly above is a variant arrangement drawn in a somewhat different style.

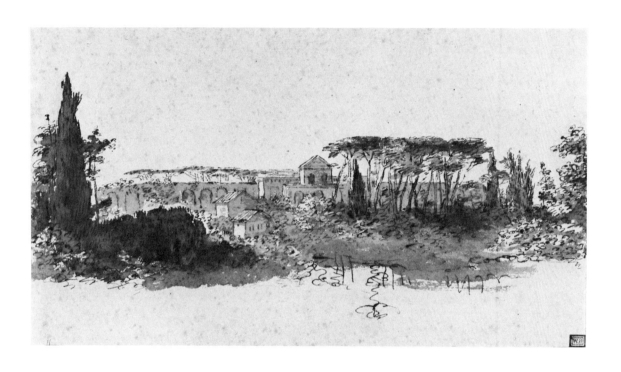

CLAUDE GELLÉE, CALLED LE LORRAIN, Nancy, Rome, Naples, 1600–1682

24. *Roman Landscape*

Pen and ink with wash on paper, 16 x 28.8 cm.

BIBLIOGRAPHY: A. Mongan, *One Hundred Master Drawings*, Cambridge, Massachusetts, 1949, p.80; Paris, no.99; Cincinnati, no.259; Guidebook, pl.190.

This drawing has been described as a view of the Villa Doria Pamphili or the Villa Ludovisi. Richard Krautheimer believes that "Claude sat in the Villa Ludovisi about where the Palazzo Margherita now is and then looked up the Via Veneto towards the Villa Borghese. The walls would then be the Mura Aureliane and the Mura di Belisario."

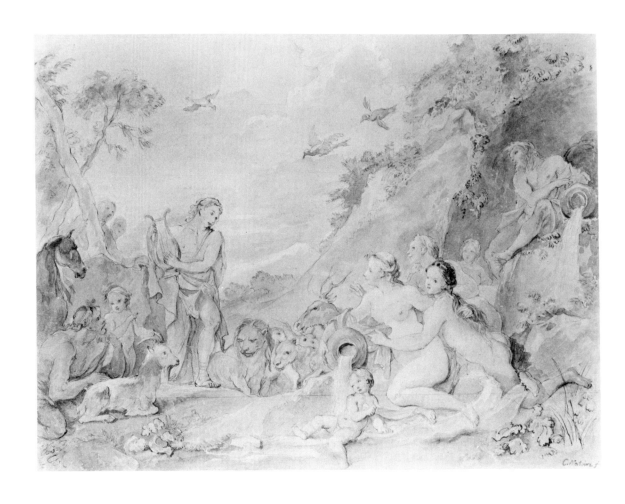

CHARLES JOSEPH NATOIRE, Nîmes, Rome, Paris, Castel Gandolfo, 1700–1777

25a. *Orpheus Charming the Nymphs and the Animals*

Pen and ink with wash and some watercolor on paper, 36.8 x 47.5 cm. Signed in lower right corner: *C. Natoire f.* On the verso: No. 25b.

Unpublished.

Traces of squaring may indicate that this was an elaborate study for a wall painting or other mural decoration. This artist was famous for his frescoes both in France and Italy.

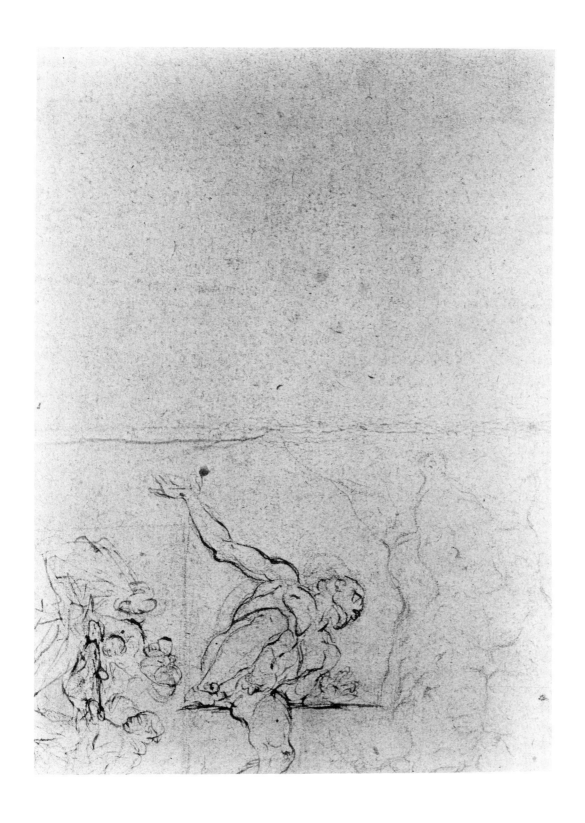

CHARLES JOSEPH NATOIRE, Nîmes, Rome, Paris, Castel Gandolfo, 1700–1777

25b. *Studies for an Adoration, a Nude Man, and Other Subjects*
Pen and ink with red chalk on paper, 36.8 x 47.5 cm. Verso of No. 25a.
Unpublished.
The posture of the naked male figure indicates that this was a study for a ceiling fresco.

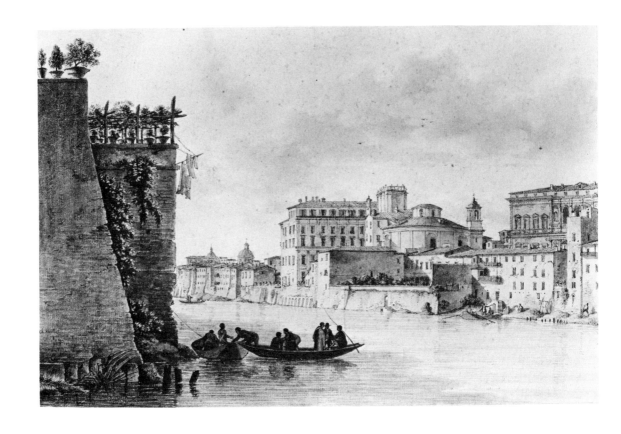

VICTOR-JEAN NICOLLE, Paris, Rome, 1754–1826

26. *View of the Tiber*

Pen and ink with watercolor washes on paper, 20.2 x 31 cm. Signed in lower left on the side of the embankment: *V. J. Nicolle.* Inscribed on the verso, probably by the artist: *Vue de Palais Falconieri et Farnese, située à la rue Julia au bord du Tibre. p. V. J. Nicolle.*

Unpublished.

One of the many views of Rome commissioned from the artist by Louis XVI.

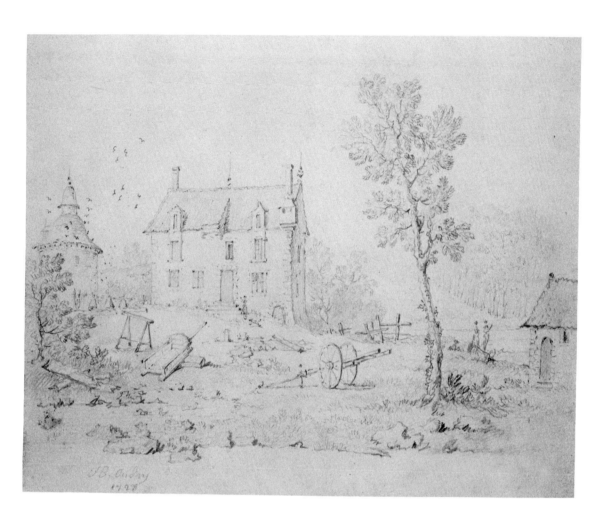

JEAN-BAPTISTE OUDRY, Paris, Beauvais, 1686–1755

27. *Country Farmhouse*

Pencil on paper, 18.8 x 23 cm. Signed and dated in lower left corner: *J.B. OUDRY 1728.*
Unpublished.

This drawing is reminiscent of seventeenth-century Flemish drawings. It demonstrates the influence of the artist's early schooling under his father, who was a pupil of Teniers the younger. Although it is not included in the most recent catalogue raisonné of Oudry's work, it is closely related to several of his paintings dated 1727 (see H. N. Opperman, *Jean Baptiste Oudry,* vol. II, New York, 1977, figs. 167, 169).

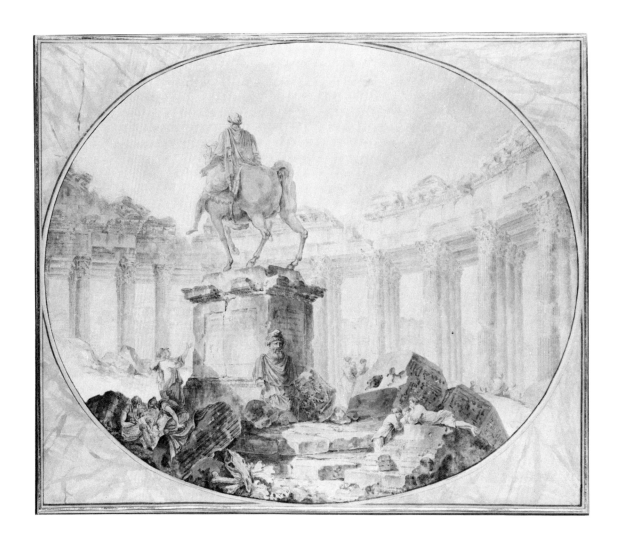

HUBERT ROBERT, Paris, Rome, 1733–1808

28. *Equestrian Statue of Hadrian*

Pen and black ink, brush with gray and brown wash, and watercolor heightened with white over black chalk on light tan paper, 48 x 58 cm. Inscribed in pen and ink on base of statue: *IMPE CAESARI DIVI/ ANTONINI/HADRIANI.* Signed at the end of inscription: *ROBERT • FECIT.* Old mat stamped: *Glomy.*

BIBLIOGRAPHY: Cincinnati, no.265; *Hubert Robert: Drawings and Watercolors*, no.2.

The composition is assembled from partial representations of the most famous monuments of Rome. The equestrian statue is that of Marcus Aurelius from the Capitol, the colonnade suggests Bernini's in St. Peter's Square. In the background on the left is the Pantheon, and on the right is a distant view of the Colosseum. This pastiche of monuments and ruins is somewhat lightened by the groups of people placed among them. The young artist made several similar compositions, some of which are dated 1757. This drawing may have also been made around that time. The old mat was marbleized in watercolor and bears the dry stamp of Glomy.

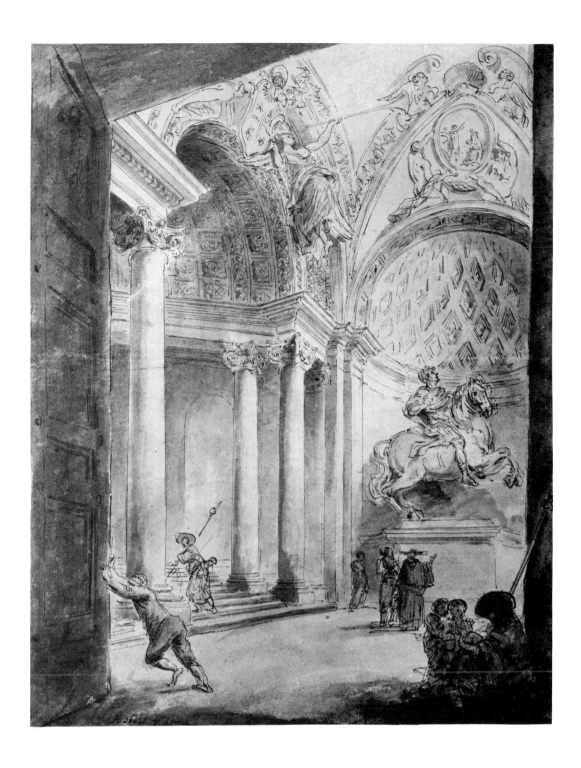

HUBERT ROBERT, Paris, Rome, 1733–1808

29. Interior of St. Peter's

Pen and black ink, brush with watercolor, and washes over sanguine on white paper, 41 x 32.1 cm. Signed in lower left corner: *Robert f roma*.

BIBLIOGRAPHY: Galerie Charpentier, *Tableaux et dessins anciens: Collection de M. Paul Chevalier*, Paris, March, 1956, no.27; Cincinnati, no.266; *Hubert Robert: Drawings and Watercolors*, no.3.

V. Carlson notes that "the equestrian statue and the figures are drawn with spirited manipulation of pen and wash, recalling Robert's drawings in this technique of circa 1760–1765." However, he dates the drawing about 1758.

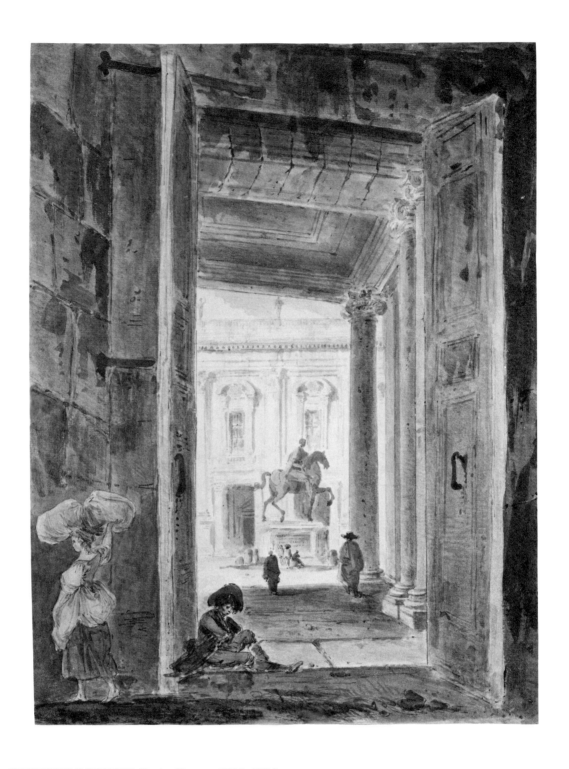

HUBERT ROBERT, Paris, Rome, 1733–1808

30. *Statue of Marcus Aurelius on the Campidoglio*

Pen and ink with watercolor over sanguine counterproof on paper, 43.5 x 33.3 cm. Inscribed on the old mat: *Robert*. Also inscribed on the verso of the old mat: *h. Robert*.

BIBLIOGRAPHY: Galerie Charpentier, *Tableaux et dessins anciens: Collection de M. Paul Chevalier,* Paris, March, 1956, no.28; The Metropolitan Museum of Art, *French Drawings from American Collections*, exhibition catalogue, New York, 1959, no.74.

The statue of Marcus Aurelius was a favorite theme of the artist. He drew it in his sketchbook of 1760 (Pierpont Morgan Library, New York) and in various finished works. The closest of these to our drawing is the one dated 1762 in the Kupferstichkabinett in Berlin (see M. Winner, *Zeichner sehen die Antike,* Berlin, 1967, pp.24–26).

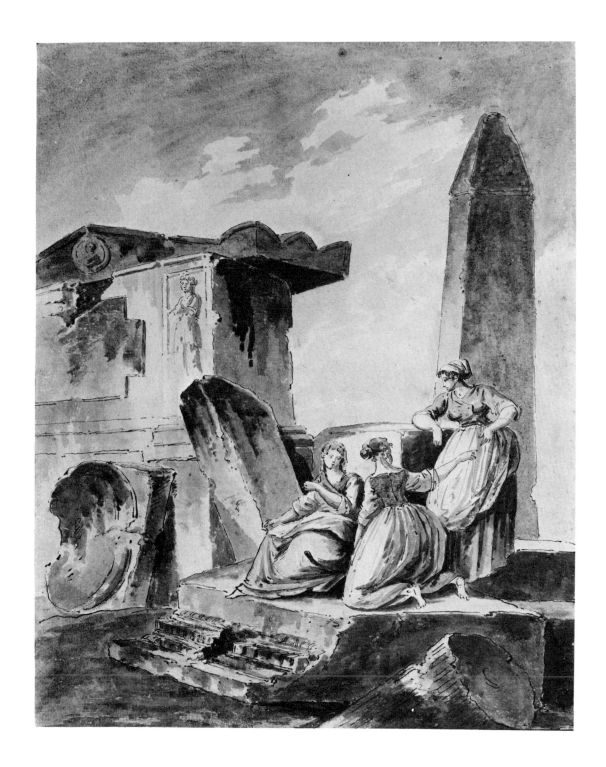

HUBERT ROBERT, Paris, Rome, 1733–1808

31. *Three Girls Among Ruins*

Pen and ink with washes and watercolor on paper, 36 x 28.6 cm.

BIBLIOGRAPHY: Galerie Charpentier, *Tableaux et dessins anciens: Collection de M. Paul Chevalier,* Paris, March, 1956, no.71.

The attribution has been questioned. The somewhat weak composition is assembled from elements copied from Robert's drawings of the 1780s.

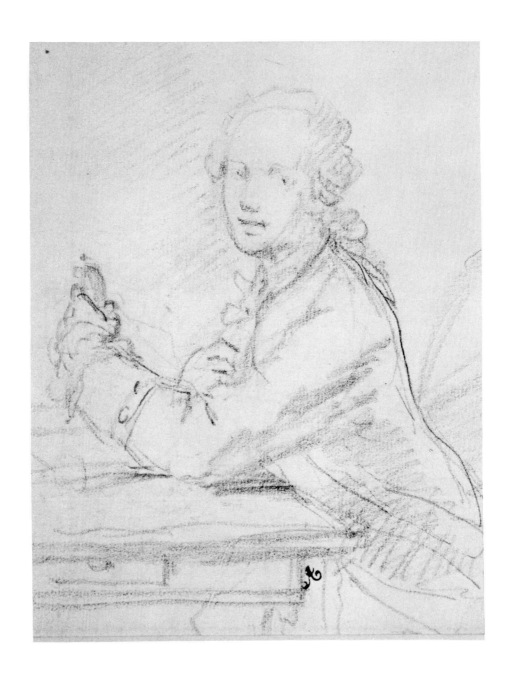

AUGUSTIN DE SAINT-AUBIN, Paris, 1736–1807

32a. *Portrait of a Young Man*

Chalk on paper, 16 x 12.3 cm. On the verso: No. 32b.

Unpublished.

It has been suggested that this might be the portrait of the artist's older brother, Gabriel de Saint-Aubin.

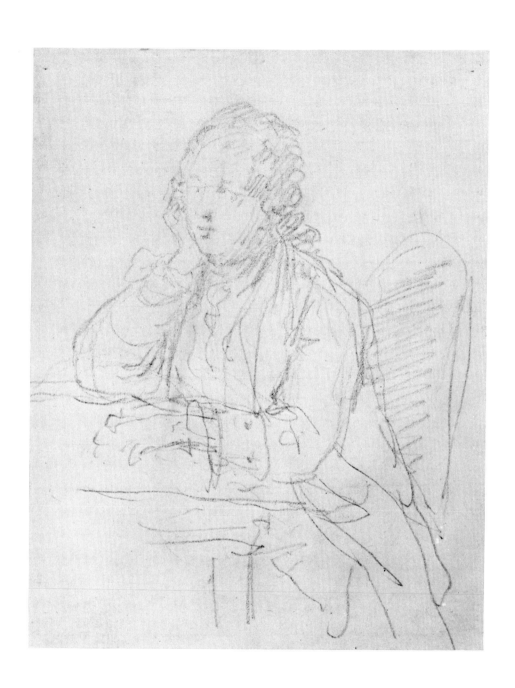

AUGUSTIN DE SAINT-AUBIN, Paris, 1736–1807
32b. *Portrait of a Young Man*
Chalk on paper, 16 x 12.3 cm. Verso of No. 32a.
Unpublished.

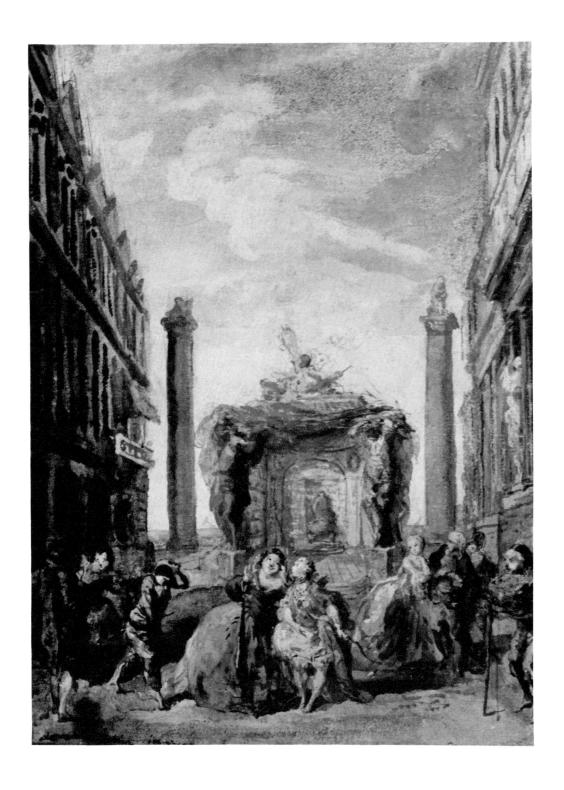

GABRIEL-JACQUES DE SAINT-AUBIN, Paris, 1724–1780

33. *Les Fêtes Vénitiennes*

Watercolor and gouache with pen and brown ink on paper, 20.3 x 15 cm. Signed in the lower left corner: *De St Aubin inv.*

BIBLIOGRAPHY: E. Dacier, *Gabriel de Saint-Aubin: Peintre, dessinateur et graveur,* vol. II, Paris, 1931, no.749; *Prints and Drawings by Gabriel de Saint-Aubin*, no.40.

The theatrical scene was identified as *Les Fêtes Vénitiennes*, one of the most celebrated ballets of the eighteenth century. The artist could have seen it at the Paris Opera in 1750 or 1759. Since the watercolor is a mature work, the later date seems to be more likely.

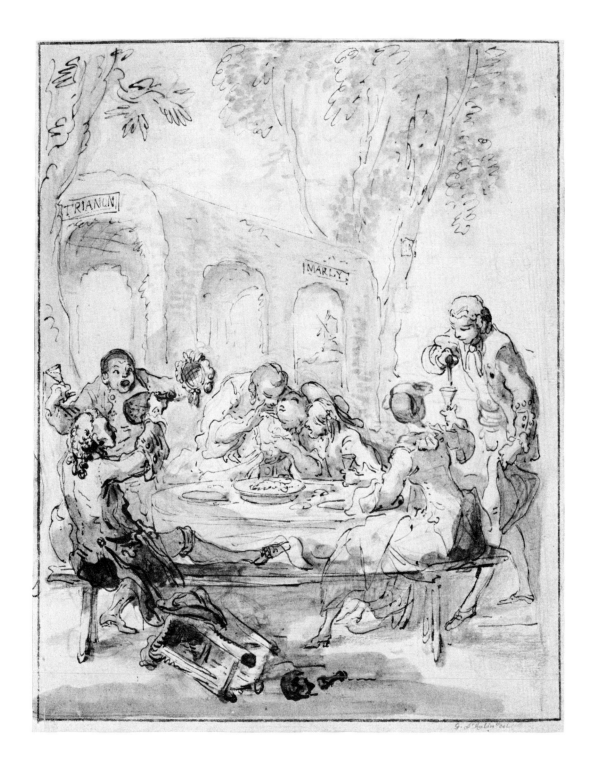

GABRIEL-JACQUES DE SAINT-AUBIN, Paris, 1724–1780

34. *Revelers at a Table in the Countryside*

Pen and brown wash over black chalk on paper, 25.6 x 19.5 cm. Inscribed in lower right corner (not by the artist): *G. St Aubin del.* Also inscribed in the composition in pen and brown ink (by the artist): *Trianon Marly.*

BIBLIOGRAPHY: S. de Ricci, *Les Chefs d'oeuvre de l'art français à l'Exposition internationale de 1937: Les Dessins français*, Paris, 1937, pl.19; *Prints and Drawings by Gabriel de Saint-Aubin*, no. 48.

It has been noted that the two names, Trianon and Marly, refer to the country estates of Louis XV. Their conspicuous placement could refer to some scandal in the court that was well known to the artist's contemporaries.

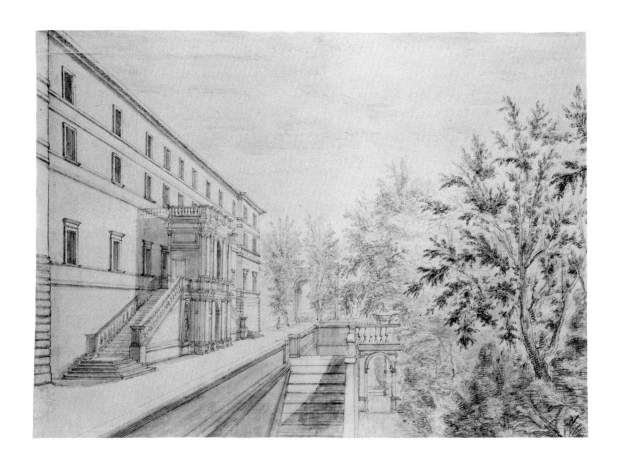

ISRAEL SILVESTRE, Nancy, Florence, Rome, Paris, 1621–1691

35. *Garden Terrace of the Villa d' Este in Tivoli*

Pen and ink with wash on paper, 33 x 47 cm.

Unpublished.

This meticulous representation of a section of the Villa d'Este was probably part of a series depicting the famous architectural monuments of Italy, which the artist undertook as a commission from Louis XIV.

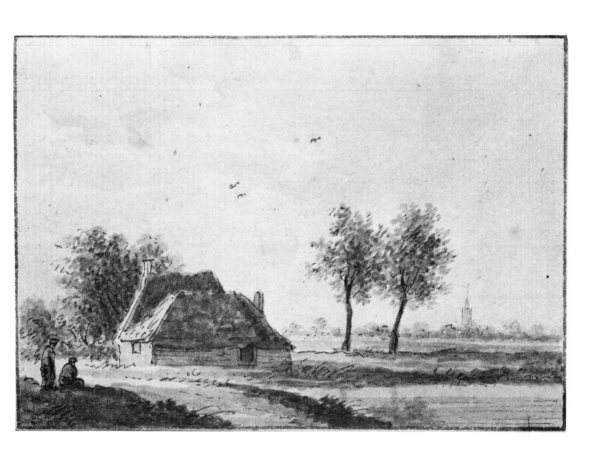

UNKNOWN FRENCH ARTIST OF THE XVIIITH CENTURY
36. *Cottage with Distant Village*
Pen and ink with watercolor on paper, 12 x 13.8 cm.
Unpublished.

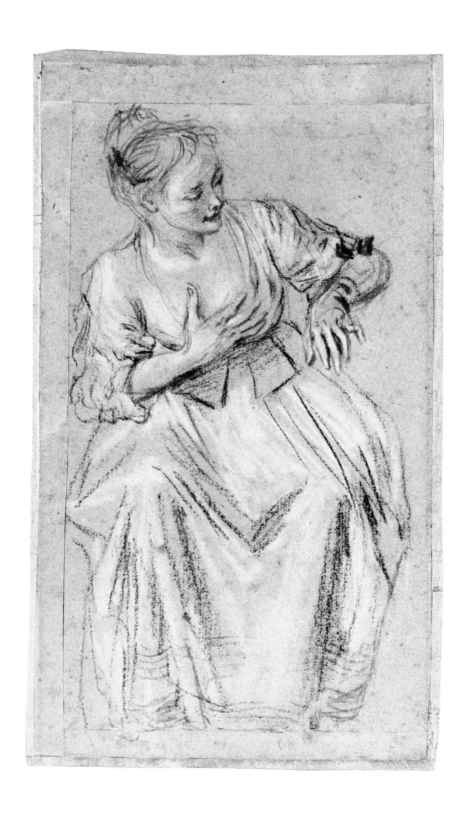

JEAN-ANTOINE WATTEAU, Valenciennes, Paris, London, 1684–1721

37. *Seated Girl with Butterfly*

Red, black, and white chalk on light brown paper, 21.7 x 12.8 cm.

BIBLIOGRAPHY: K.T. Parker and J. Mathey, *Antoine Watteau: Catalogue complet de son oeuvre dessiné*, vol. II, Paris, 1957, no.556, p.310.

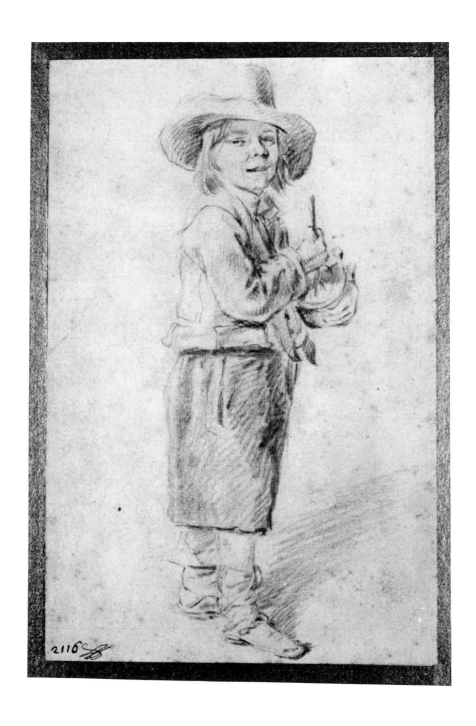

JEAN-ANTOINE WATTEAU, Valenciennes, Paris, London, 1684–1721

38. *The Rommel Pot Player*

Red chalk on paper, 17 x 11.1 cm. Inscribed in lower left corner: *2116 PC.*

BIBLIOGRAPHY: "Current and Forthcoming Exhibitions," *The Burlington Magazine* 103 (1961), p.358, no.39.

This drawing is probably a copy from a seventeenth-century Dutch or Flemish painting. It has also been suggested that it might have been cut from the left side of a larger sheet now in a private collection (K.T. Parker and J. Mathey, *Antoine Watteau: Catalogue complet de son oeuvre dessiné*, vol. I, Paris, 1957, no.320).

WORKS ABBREVIATED

A. Ananoff, *L'Oeuvre dessiné*

Ananoff, Alexandre. *L'Oeuvre dessiné de Jean-Honoré Fragonard 1732–1806*. 4 vols. Paris, 1961–70.

Prints and Drawings by Gabriel de Saint-Aubin

Carlson, Victor, D'Oench, Ellen, and Field, Richard S. *Prints and Drawings by Gabriel de Saint-Aubin*, exhibition catalogue. Middletown, Ct., Davison Art Center, 1975.

Hubert Robert: Drawings and Watercolors

Carlson, Victor. *Hubert Robert: Drawings and Watercolors*, exhibition catalogue. Washington, D.C., National Gallery of Art, 1978.

Cincinnati

Cincinnati Art Museum. *The Lehman Collection, New York*, exhibition catalogue, 1959.

Paris

Paris, Musée de l'Orangerie. *Exposition de la collection Lehman de New York*, exhibition catalogue. Paris, 1957.

R. de Portalis, *Fragonard*

Portalis, Roger de. *Fragonard: Sa vie et son oeuvre*. 2 vols. Paris, 1889.

Guidebook

Szabo, George. *The Robert Lehman Collection, a Guide*. New York, The Metropolitan Museum of Art, 1975.

Drawings by Fragonard in North American Collections

Williams, Eunice. *Drawings by Fragonard in North American Collections*, exhibition catalogue. Washington, D.C., National Gallery of Art, 1978.